Cloud Seeding Agent

Cloud Seeding Agent

Collected Poems (2013-2019)

By Yin Xiaoyuan

PINYON PUBLISHING

Montrose, Colorado

Cover Art by CHEN Shui

Interior Art by
CHEN Shui, DENG Xiang, Ölmalerico, John Charles RYAN,
Jason SHEN, WANG Jun, XIA Haitao, & ZHANG Wanchang

Black & White Photograph of YIN Xiaoyuan by SONG Zuifa
(Holder of the 1st Class Photographer National Certificate, Editor of "The Face of Chinese Poetry" Series)

Color Photograph of YIN Xiaoyuan by YIN Xiaoyuan
(Changbai Mountain, 9,003 ft, near Heaven Lake)

Design by Susan ENTSMINGER & YIN Xiaoyuan
Using Pantone Colors of the Year:
Tangerine Tango (2012) Living Coral (2019) Mimosa (2009) Sand Dollar (2006) Cerulean (2000)
Rose Quartz and Serenity (2016) Greenery (2017)

First Edition: February 2020

Pinyon Publishing, Montrose, CO 81403
www.pinyon-publishing.com

Library of Congress Control Number: 2019957206
ISBN: 978-1-936671-60-1

Contents

ODE TO PRIME NUMBERS

Your name is 'le seul.'

Undeconstructible and enigmatically unyielding.

As straight as a feather, vividly white as well, is the fragment of bone in the depth of entwined source codes. You never know since when the lips of the cognoscenti started testing on you: They longed to know how the fluttering sequences of binary numbers smell, which scintillate between positive and negative infinity. Ambery? Or just intoxicatingly oriental?

Their coarseness hampered their forlorn attempt to reach you; their lust to disassemble left them nothing but despair and dirty, worn gloves.

Just as Alphonse de Polignac once said: There is a mirror image of you in the fathomless universe, forever 2 degrees apart from where you are located. You almost felt her sometimes … You have spared no vision or hearing in your exploratory search for her: yet you sank into an ocean of molecules—banal replicas of one another, and then a moor of double helixes blooming and withering ephemerally. All you could see is waving hyphae, stretching along fissures between clusters of stars, whose glimmers tasted so antiquely astringent!

You were chosen out of all others since you were a ripe embryo. Time-roughened hands with sophisticate calmness, combed through and smoothed out kernels of corn, like what Fate did to centillion bytes of data. The blazing ibis from the east condescended to them like a flash of wisdom—devoutly before her they winnowed away chaff and dust, while you clung to the center of the giant mesh, like a rare butterfly … They let you nestle up among their fingers, held you to the light and murmured with a Mediterranean accent: "Ciao!"

The streets that have supplied you with all colors and sounds of life are in a parallel system to theirs. When you saunter down to the seaside, hands in pockets, local people approaching you with buckets of olives and sardines cannot actually meet you, as if you were walking past this place at different times of day. They indulge in their neon nights while you embrace your sapphire days. Gradually you turn from strangers to dancing partners, lovers and then rivals, in the revelry of darkness!

Growth curves of everything are invisible, but to the stars they appear as emerald waves, rising from feebleness to

robustness, soaring marvelously, and then plunging, increasingly close to zero. Just as what the frequency of prime numbers reveals, they end up in decay as you end up in solitude. You are destined to be the last celestial body over seven thousand miles of graveyards.

[Voice-over 1] When you glanced away beyond tracks of time, suddenly he came into view, emerging from underneath the surface of the ethereal, gleaming with vigor and tenacity. Those attributes of his do not perish with the body, or even with the soul. He is incarnated everywhere, in weather, energy, and even Zen. A roots-stems-leaves theory could never demystify the origin of him or the canopy above, which could be traced back to Hadean time.

[Voice-over 2] Compared to the entire history of time, phantasmagoric voices rustling through those lines are nothing but drops of liquid in vascular bundles of the universe. Ears which hear them would turn away shyly like autumn leaves. When there drips out mercury, whoever its sound reaches will be doomed.

[Voice-over 3] It has been kept secret, that the Fate of the human race had been long predicted, by the final scale the convex meniscus rose to.

32-BIT COLOR DEPTH

(An announcement: The Color Test System has been activated. This is the first warning. Please return to your rooms.)

"Have you noticed it? What we are in is not a hotel.

The scarlet velvet couches, dark golden carpets, and chandeliers are but a camouflage—

This is an institution. It seems other buildings are only a green belt away, but you can never take a step outwards."

(Eyes blood-red, he grasped a glass of Depth Charge from the trolley and gulped it down.)

A piece of cloth was clipped to the board sent to your room—Purple, neatly cut.

"Why is purple a possible outcome?"

A Jacaranda tree by the window sprayed sparks in the storm, scratching the sky, and made it bleed …

What kind of personality are you? Red or blue? They are diffused into each other this very moment.

Look at those pieces of porcelain! They are neutralizing one another, their outlines mixing—

A spindle-shaped vase and a napkin box mixed into some scallop-shaped ware.

Moving, rustling, on the boundary between light and shadow.

A hypocrite lobby manager and a grumpy woman mixed into the sullen guest in room 1037.

The last person stepping out of the elevator adhered to the wall

—like a potato wrapped in candied floss. "Help! " she cried.

But there was nothing you could do. The outlines of everything were opening up towards the infinite,

while borderlines between colors shattered.

"This company, emerging from nowhere, has pronounced their breaking the bottleneck of Photoshop,

by successfully making 32-bit pictures,

which is definitely an astounding breakthrough:

A gradient has replaced a color atlas."

Veronica's irises are like the Grand Prismatic Spring: emerald in the middle, garnet on the outer ring, and mustard at the edge …

Men drown in them described them as "a crescendo of hues," in which he witnessed his own soul being detached from his flesh.

Window frames shimmered with mercury luster.

They drew the curtains wide and felt the world outside:

"Super-5-star luxury and lustration, in the year 2023 we opened outlines of objects …"

—Those are letters written on the scrolls, hanging from the top of this skyscraper.

You were born and imprisoned in such a picture,

brighter than you were in your previous life, but remained odorless.

TO KILL A PROCESS

To make rolls with caviar, lemon, and dill;

To dive into the hinterland of a railway timetable in hope of catching a black-headed gull underneath;

To set a clock to your biological clock; to filter the trickling sunshine with Chemex paper;

To double-check tone needs with a copy machine; to keep your battery charged with water and pure air …

Steps to take:

Start Task Manager by Ctrl+Alt+Delete. Set priorities.

Cut, sand, and polish—with resolution.

Shreds floating in the air tried to form new logics: To catch the smell of dill with Chemex paper and set its tone to your needs …

The clock is always the last thing to deal with. (After all, it is not the clock in Benjamin Button's story that runs backwards.)

To kill a process—unsuccessfully. Just confusing multithreading.

You were in a jam between static and possible velocity.

A sign sent from outside: Cover of the Enigma Album—

Seven Lives Many Faces

"Are you good at Excel?"

"Just so-so."

"Expand the selection

before you sort a column,

or the data no longer match up."

(There is a sin in making a cell …)

—Why could a caviar roll be

attuned to "double helix of time,"

and a conversation with the copy machine

possibly "give sunshine a honey hue?"

"Wheat is ripe when seasons

were interwoven within,

while the copy machine harbored

vagrant colors around."

PLAIN TEXT

"Discarding formats is as difficult as dismantling wooden brackets."
—Anonymous: Text Purification Journals

Cotton-white, velvet-soft, outlines brisk, matt surface.

He had read these Nordic-style instructions 27 times:

He did it in the shadows of some railway station, in the suspense before a bell rang,

or in front of an acrylic-on-canvas of water lilies.

—but still missing the point. "It is as plain as a pickup note,

something lying between you and what you desire."

"The holy definition of a name is the most precise description for the contents in the bronze trunk."

The postman who delivered it here was in a dark-green double-breasted coat with golden buttons—like a hotel porter.

A wine-red piece of cloth spread over the trunk was embossed with patterns, on which embroidery and tassels shone.

A thief etched them all off during the night: They were acidic characters, experts at eating away enamel of the moon.

Its aeruginous body was thus exposed—then its skeleton, thrusting out the thinnest parts of the wooden crust.

People swarmed up and dismantled it like dismantling a movie studio backlot before a wrap party.

White gloves knocking off verdigris; drilling through the wood, disassembling the bones.

Like illusions produced by two mirrors facing each other, they reproduced themselves even more desperately, infinitude was born.

There was a pair of albino elephants, which no one has ever seen.

As white as silk, they could make people snow-blind.

They were worn away, the instant light laid its fingers on them.

13 ITEMS IN THE START MENU

Common Applications:

A. Biological Clock.

Autorun self-debugging function.

Full warranty (including fine adjustment service) for 40 years since date of original installation.

Its service life varies based on climatic zones, precipitation, pH, temperament, jet-lag traumas, and system junk.

The default value is "local time," free to switch when in multi-regional mode.

B. Single-timeline Memory.

When a parameter changes, mass begins accumulating in an alternative space-time, as its inverse function.

"Add-up" mode for skills and "overwrite" for emotions.

Self-destruction process is started when the system is experiencing a shutdown,

which inevitably swallows unique techniques and family heirlooms.

As a built-in APP, its values are modifiable. No longer guaranteed once rooted.

C. Self-protective / self-destructive mechanism.

The former includes psychological projection/compensation, selective amnesia, pain, and immunity;

the latter "cell autophagy" and "TRAIL receptor" etc.

Customizable Software Packages:

D. Human Nature.

Its beta version is formally released at age 18, an infamous bug-ridden OS, extremely susceptible to Trojans and viruses.

The only APP with one-key recovery function.

(It is said "By laying down weapons one restores Buddhist sedateness.")

E. Intelligence.

Usually categorized as a news or social APP,

but actually an image-and-video editing APP, processing megabytes of complicated data in a twinkling.

Unaffected by races, genders, or religions, which influence only the user-interfaces.

F. Temperament.

In contrast to its low priority, its memory usage is bewildering, which sometimes leads to motherboard damage.

There are several set menus, on which George Gurdjieff and Jung & Myers-Briggs kept arguing on for over a century.

G. Gender.

One's physical gender is like anti-virus software, starts automatically and unable to be terminated;

while psychological gender is like Windows, it keeps updating itself.

Random APPs:

H. Fortune.

When used in the sense of "destiny" it is a read-only document,

can be opened only by an exclusive reader (pay-on-demand) named FortuneTeller.

When used in the sense of "wealth" it is a kind of office software, with pop-up ads including stock and lottery information,

which are clicked by mistake by novices from time to time.

I. Love.

An APP like Mafia Mystery—a game involving conspiracies, suspensions, and judgments,

in which there are roles including killers, doctors, cops, and civilians.

Every player regards himself a breaker of conventions but eventually ends up with a preset outcome.

J. Lifespan.

A Russian roulettish APP.

Nutritionists, alchemists, phrenologists, and geomancers claim it to be a calculator APP,

for which they can get a better result from the same base number when the fact is:

contingencies contribute more to it than predictable factors do.

It definitely has a maximum value—yet unknown and a minimum value—0, so nobody has ever been in the red.

Others:

K. Innocence.

A kind of translation software that simplifies almost everything, and filters outdated habits, prejudices, and lies.

Incompatible with most other APPs, often manually terminated as people grow older.

V1.1.0x0y_a_V.7.2.1231_release can even decrypt garbled messages, which has a nickname—"WonderChild."

Versions after that were equipped with richer vocabularies but their keyword-recognizing functions have disappointedly retrograded.

L. Charisma.

It is metabolism, consistent data-exchanging with the world outside, that made a man radiating charm.

This APP is like a weather APP in a way, eloquent and persuasive but error-prone.

Its icon can be placed on the desktop as a decoration.

M. Features.

As the saying goes "The soul is the creator of the features."

It is something like Autodesk Maya, depicting a person with parameters.

A for his vitality, D for his expressions, F and L for his charm, I for his gentleness, and K for his youthfulness …

Miracles can happen to a man with balanced parameters.

A DAY AMONG UNACQUAINTED FIREWALLS

It was late autumn, when vines of lightning climbing down through the windows turned red.

Carpenters hit the walls with square hammers but barely scratched them: "Remarkably solid."

For a moment was he assured that fireworks of noises were all shut out, where they faded and were chilled thoroughly.

When he summoned these words he suspended himself in the moonlit minty air outside, like a frost-covered ghost.

Security Level: Low

Shadows emerging from the horizon flooded over the streets and church spires.

A cast of crabs, a field of *Rafflesia arnoldii* flowers, or just wisps of Mansonesque lines.

They applied grinding wheels to his mortal frame, sanding off his coarse wrappers, eating all bulbs and roots in his territory.

Window glass grew scalding, ready to grill.—They ended up as rags on a clothesline.

Security Level: Medium

He received a message—"I've been outside for 3 days. I wonder why you keep neglecting me.

I saw you drawing the brocade drapes, your eyes following the track of the sun … Now I'm as dried as roselle flowers."

Security Level: High

A giant jellyfish rose like floating candles—the surface blacked out.

A constellation grew in the dimness like coral reef—the surface blacked out.

A ghost ship skimmed over and scared off seagulls—the surface blacked out.

… It never lit up any more.

He stayed in the quiescent darkness

for 30 minutes, or 30 hours—

the flowing of time is so intangible.

This will be one of the scenes in his biography,

with the chapter title—"Finally Safe."

He was found slumped over his keyboard.

The computer was on,

a formula calculation running on the screen.

Waves of characters

overlapping and erasing one another.

Task Manager showed:

There was no "currently running program."

As serene as a smile after the curtain call.

REMOTE ASSISTANCE

Alpha Man's Twitter; Alpha Woman's LinkedIn; Beta Man's Troubleshooting Ticket;

Gamma Man's iCloud and Facebook; Beta Woman's Wolfram Mathematica.

—Like a tropical cyclone, you hovered over them, perspicaciously witnessing everything, from God's perspective.

Alpha Woman's B-girl; Alpha Man's Angel Fall wing-suiting; Beta Man's Gordian Knot;

Reticent Gamma Man's Dutch courage; Workaholic Beta Woman's Lemniscate of Bernoulli;

Kagemusha Gamma Woman's Neve Mic Preamp; Delta Man's tour into Antelope Canyon; Epsilon Man's encrypted bucket list;

Delta Woman's Marathon military watch, which she threw to the glaciers.

The unobvious cross-shaped notches beside their spirals were the passages whereby you used to enter,

put on their bones and muscles, IDs, experiences, and life dramas.

(Scarlet positive charges and blue negative charges dashing along the sky crushed into each other,

and the arc discharge could blast over a truck.)

It was you, who did all the headspins, superman windmills, and boomerangs,

while Gamma Man sat in the audience, blooming like yucca in the dusk.

You cut the knot of love like Alexander the Great when you said farewell to her on top of Mount Elbrus.

You were soaked in the infatuating glimmers of the dawn among the red sandstones,

wearing an antique ring discovered somewhere by clues Epsilon Man had left.

Once you said, there were two things you loved besides Mathematics: Alpha Man's wild wings and Gamma Woman's gothic metal

"The personality integration was implemented. Or something just dawned upon me."

Gamma Man has rich and telegenic body languages: "Believe me, everything I did, I did it of my own free will."

His bones are too strong to be hollowed out gradually by age. His lips are lusciously plump and face radiant.

—She has no idea how you had acted as the only pivot in the windmilling.

They put themselves in your hands. So mercifully, you made turbulent torrents of time stop for them to swim across.

You let them off easily—again.

RELATIVE COORDINATES OF YOUR DIVINE SELF

When you were born, your coordinates relative to Divinity were: (@0 , 0 , -30).

Yes, He was floating in the air, surrounded in his halo, 30 meters over your head.

The surface of an unfamiliar matrix was always level with those of old major waterbodies.

There seraphs took shape of humankind, carrying water in jars. Viverridae, Procyonidae, Hyaenidae …

New names originated, when mountains rose and valleys fell.

Touches of spring on the wild were as pompous as crushed butterflies.

Driving along a twisting Lancashire road, as rough as bleached denim,

the sunshine flew down, to the abysmal emptiness you used to keep yourself from.

—It was a slight metallic sound that gave you an ecstatic thrill.

The phantom island of Tonga once surfaced before your eyes like a shark from an ink-blue ocean.

Hisses and crackles. Swifts broke away from the ethereal draperies and glided down to the abysm for afterglows.

Rumbles. A panther couple dived to the bottom, inviting Evil to be their witness.

They dwindled like paper-cut figures. In the bitter wind, the earth beneath you vanished like a hallucination.

You were just in time for His ascending. Again, He was right there, 30 meters over your head.

PLANE-CHANGING METHOD

He is your Vitruvian Man. Looking horizontally at him:

He is your height scale with those ivory ribs.

You have sketched him as a reflection: from his shinbones, knee caps, up his navel, to his chin and feathers around his head.

White flowers dropping down Cinchona trees flew out of the mirror like rock salt, their off-season blooming must be a sign.

From bottom to top, you overelaborated him: with painted pottery, turquoises, and thunderbird totems.

One more handful of dust under your feet, you will be able to reach his eyes for your finishing touch within.

When will the volcanic ashes fall to the ground? This does not fall within the scope of process control.

His constitution between ancient ice and solid rock,

His features like dry valleys and blind valleys. The karst crust will eventually cave in,

—So upset you are, like a slave who casts pharaohs' masks.

You said THAT name, squeezing the bitter voices from bottoms of your lungs, like an underground river.

No one steps from behind the oil strokes—that was your own secret name,

which you can hide in your pocket now, like what a thief would do.

Only two more centimeters, you will be of the same height as he,

looking into his eyes, which open and gaze down at the transient world.

You added a lock of your blackcurrant hair to him in the end.

It is in the dead of the night right now
—with sunshine drifting above,
stars sinking in the depth of murkiness.
You cannot wait to open the door
—(your cottage is on the mountain top,
like a weather-beaten coffin)
You must kiss and burn it, in the wind.
Crying. Deep-breathing.
On the dial of the world displays
your body temperature and altitude.

3 VIEWS

A ray of white light shed down in the crowd, and the hoary Man rose from the ground.

His soul, which had remained an irregular body, flattened itself softly like an ivory carton.

Unfolded like scrolls, the ephemeral information of the human flesh was wiped off.

Horizontal Plane:

Chemist addicted to cherries (Once he mentioned his preference for cyanogenic glycosides) and anisette.

Conceited listener and pungent speaker. Falsificator of Phaistos Disc.

Hard-core fan of Pablo Casals who loves inverted turns better than salons.

Greyhound trainer. Man with a mild dependence to oceanic climate.

Savvy SLR enthusiast, who is known for his "an-alarm-is-a-command" idiosyncrasy.

Vertical Plane:

Grizzled man. Dweller in the twilight zone by the coast.

Non-socializer, homogeneity recognizer.

Unprotected walker through Romance virus epidemic area (orange road sign).

Man who overstayed his health guarantee period (His price tag was time-bleached when recycled).

Width Plane:

Lone wolf. Bad contributor to gossipism.

OCD, WWII PTSD patient (He was trying to cover his gradual deafness with lordliness).

Liquor glamorizer. Dark-wave vinyl collector. Confusing behavior patterns.

Human race as mortal as us.

V & H: equal length—An ascetic

V & W: equal height Owner of wines, music and habits

H & W: equal width—king of solitude

INTERSECTION LINES

They are all true and real:

Flowers covered by frost, gelatinous sky drooping low, boats drifting between olive-green islands …

Why are there furrows and creases on the surface of this aquamarine-blue planet?

It is between you and her. A ridge, different from that of a mountain or a roof,

bleak and sheer, where gravity experiments fail and earth's magnetism disappears,

like daylight slipping away from your grasp.

(On the darker side of the earth, Bermuda is sinking with cables of suspension bridges,

entangled with sparks in your dreams, one of which was drawn across your neighborhood.)

Earth's magnetism? A child said, the bottom of an ocean must be striped

with magnetic lines like a zebra. You sent him off,

with the high kick of *The Truman Show*, which had left a water line on his back, between him and the deceased

It is so obvious, the angle between your standpoint and the purple peaks beyond, 150 degrees or so,

are in different gravity systems, even different latitude-and-longitude coordinate systems

"Instead of a perfect globe constructed by individual-centered developable surfaces,

the world is a mass made up of various intersecting spheres."

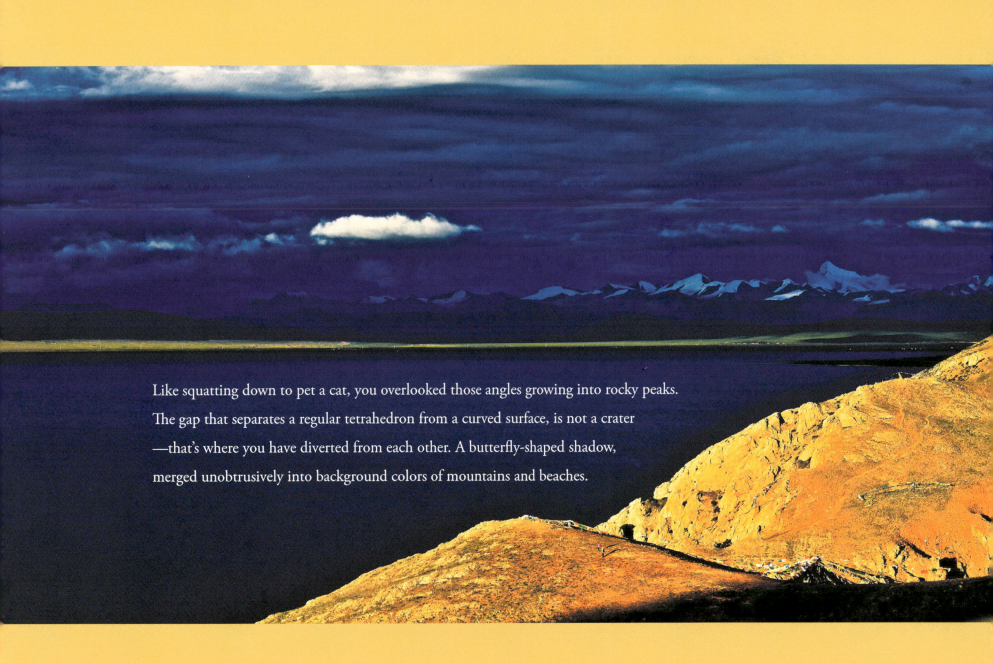

Like squatting down to pet a cat, you overlooked those angles growing into rocky peaks.
The gap that separates a regular tetrahedron from a curved surface, is not a crater
—that's where you have diverted from each other. A butterfly-shaped shadow,
merged unobtrusively into background colors of mountains and beaches.

ALTERNATING CURRENT, EITHER TURBULENT OR SERENE

On the beach, you asked the man in grayish windbreaker:

"How do you define 'The Will'?"

He drew a sine wave with his finger in the sand, then wiped it away

With waves at his command. A capful of vinegar, and seething calories of vegetables

In your stomach, turning and burning, gave you the illusion

Of snakes slithering away somewhere behind. Last night on your way home,

There was a repeat of the scene, in which she refused to allow you

To touch her rain drenched violin. "Keep your distance, am I clear?

Only one of the strings is the zero line, you just can't tell which!" She smiled weirdly

And ran upstairs. The string which snapped during the performance

Dragged along behind her, was as thick as a towrope. Confused, standing still there,

You tossed a coin into the air, and heard it

Droning fast, with strong and weak beats, alternating,

A downpour and a flood—overflowing in different directions.

Fourteen days are needed to dry your nets, and clear

All water-level data. Landforms, temperature, light from above

And your masculinity, will be turned inside out like a coat
On the other side of the globe.

CONSERVATION OF MOMENTUM, A BREAK EVEN TRAGICOMEDY

There was a mysterious loss in both chips and audience. Last season

Of blooming vanillas in the boxing ring, were swept aside by a gust of wind

After the final whistle. The assistant has confirmed, turquoise is the complementary color

Of cherry. After an avalanche of physical strength

Theater drapes are down. He cut a verdant piece from the center,

And earnestly bartered it for the violet one from his opponent,

At which moment, numbers appeared on the LCD screen of Vidameter—

One positive and the other negative. "A universe unwilling to yield to rippleless quiescence

Has ripped itself into two—a convex-concave couple."

In his memoirs he wrote: "As if me and my fists, trapped in a bottle,

Only a chimney left there to sniff some afterglow in with.

They have been with me for years,

Like bulky and loyal wolfhounds. Yet if we had toiled on

In the same direction, they will be taking up

The total momentum, while I drop dead and rot. Only a divergence of directions

Strengthen us both." (Kissing the championship ring
On his middle finger): "Farewell buddy!
Once and for all!"

CENTRIPETAL FORCE

The city, in the distant golden jungle of a magnificent sunset,

Now radiating light, now gliding

Below zero. A coast road against faint streaks of dawn is a symbol

Of the elapse of time. Mine diggers in cotton or linen

Passed by, baskets on shoulders,

Baring their birch-hued teeth. Whirring wheels underneath you

In whiffs of zephyr, were like bulls in

A field of wheat. A pat of butter and a flask of tea tree oil

Were what you carried in your pocket, to sooth the mocking axis,

When you flipped dust of all things off

From your leather gauntlets. "Her jewelry and glances are as old as

Roots of banyan trees. Through a wormhole she communicates with the city

Three hundred years ago …" Bizarre songs they sang.

You founded yourself still. Fallen leaves rolled up

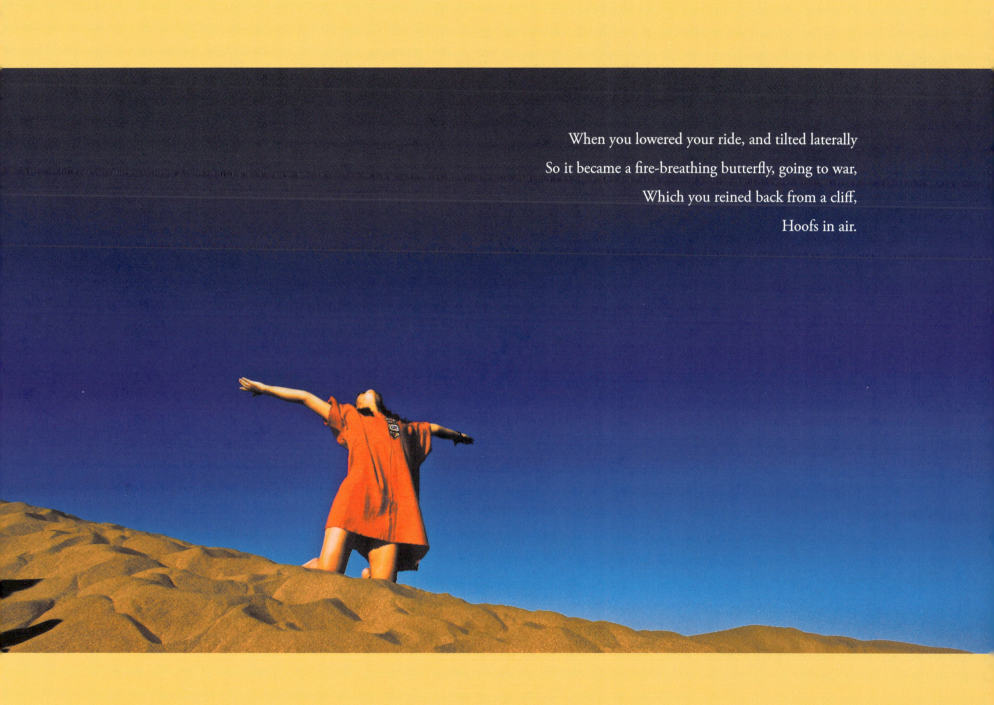

When you lowered your ride, and tilted laterally

So it became a fire-breathing butterfly, going to war,

Which you reined back from a cliff,

Hoofs in air.

WAVE-PARTICLE DUALITY FOR EXISTENCE

Socotra dragon trees, engulfed in the depth of ever fuming afterglow,

Brace up its grand arch, against a background of wasteland,

Ribbons of light are wrapped around. Buntings got brilliance and darkness

As camouflage. Desert roses, caudex vase shaped, carmine flowers dipped

Into the sun, were fused into

Grand yet capricious clouds. You had planned to cut across time

—Crow's flight, wiping off thorns, keen edges, and even

Weight of your streamlines. Now clusters of sunshine, leap up from all directions,

Like sailfishes do. It is the aromatic plants

Robust and drought-tolerant, which share constant load on the land,

When you walk along. A journey long-range and eternal

Should be slowed down, linear to punctiform. Moments of seclusion

Flash across the eyes of seabirds. When you unpack your entire life

On the shore, like windblown sleet, froth and foam will rise

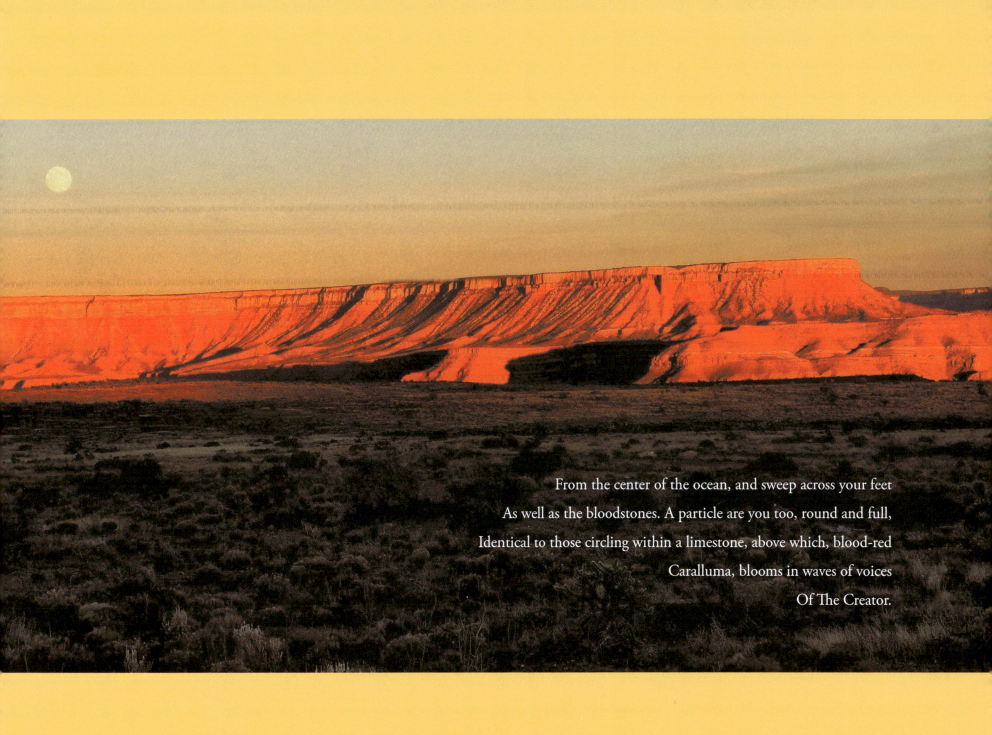

From the center of the ocean, and sweep across your feet

As well as the bloodstones. A particle are you too, round and full,

Identical to those circling within a limestone, above which, blood-red

Caralluma, blooms in waves of voices

Of The Creator.

AZURE 17,000 K

Azure sky was born

Only divinity bloomed

Sunny **all** other lights ebbed away

Caught in **the** crossfire between water and fire

Into the tropics **red-billed** oxpeckers **and** hunters going astray

Virtues of a lagoon **filtered** flame colors **while** produced sediment

Boundary line **warm & cool** colors **9500 K** at this altitude

Soaring sunlight **Bat-silhouetted** clouds **orange** and white pixels

Wet photosensitive **films lemon-like** hue **halfway** into the morning

Leaf shutters of the **surface were open, glance upward and** embrace your light!

Burned their fingers **and irises, where flashes took shape** of a shoal of fish

From tungsten to **fluorescent, light between their palms,** colorless, odorless

Swim bladders **filled with light floated above halcyon** polar twilight

In mangrove **swamps seedlings fell from the canopy** like spiders did

Bass mix of **2640 K feverish, metallic summer** night hovered aloof

As color **temperature range expands** spike moss awaits water

The scent of **flint tools lingered on** Cavemen's feast

Ashes of the **homeothermic drifted** in the wind

Great Blue **Turacos roused first** sparks

A blackbody **unfolded its** swirls while

THE MASK AND THE MENISCUS

O flourishing container of vicissitudes, nonwettable

By years leaking away. When you dived underneath,

A train of glimmering fluffy bubbles rose

Beneath your wings. Silvery, jasmine white

When you fortuitously surfaced.

Through the narrow corridor, torrential fate took lead.

The meniscus, a concave one,

Weighed upon by breezes and rays of light,

While *Amyris balsamifera*, convex, a critical moment

Before Cambrian Explosion took place.

"Surface tension is the will to withstand time and tide."

When its value greater than self-healing ability (The Resilience) within,

Our faces become masks.

THE GOD PARTICLE, OR A TEASPOON OF UNKNOWN ELEMENTS

Defined as marrow of shapes, mass will inevitably function as

A source of light, casting influence upon its worshipers

Snaking through the desert

A universe suffused with gluons, photons, and mesons—

Before this mantis-headed alien with one quark on either side

Emerged. A profusion of substances exerts a gravitational force

On the three-dimensional ocean of existence. "Out of string theory, 11 dimensions

Have loomed up, while beneath iris cells of a compound eye,

Its name remains a complex, made up of mirror images and fluffy clouds."

In this spacetime, particles with hard cores and bright rings, cavities and RBC structure

Teem like annelids. 61 elementary particles,

With shadows hemispherical, spherical, biconcave, or even catenoid,

A spoonful is too much, since arguments on color charges

Left them in discord. They had been lingering on the edge,

Until catalyzed by God—Just in the way souls combine with bodies,

They were blessed with gravity and speed.

MASS AND ENERGY

In the reference frame of a gloomy day, you decided to fold

Your translucent self. Beams should be interrupted

Before activating the golden sesame seeds within.

With your parallels, you were planted within a fan shaped nebula

As a splendid distraction. Parts once tucked in

Have sprouted elsewhere, while whispers echoing in a hollow

Have taken the form of an atmospheric phenomenon

Across the warped spacetime fabric. Substances overcrowded

Shut their shadows inside the core. Mass is but a superset of

Sources and targets, its links take off chronologically

And form a beeline, like dancing needles driven

By magnetism. You are an empty cocoon now, whose silk

Floats in space. The closer to the speed of light you are,

The closer to the edge of vanishing you become.

QUANTUM WALK

Man with [ginger-hued fingers][standard biological clock][recluse mind][decrepit lungs]

Man with [jade-hued fingers][oversped biological clock][moderate mind][fresh lungs]

Man with [jade-hued fingers][disordered biological clock][fractured mind][stout lungs]

 …

HE formulated them as above until the scarlet scrawl zigzagged

Beyond the ever stretching wall, while between the curves he remarked

In smaller font size: "Only for reference as gender-specific samples,

Applied equally to females, even humans in preceding or subsequent historical stages." Quanta without features

Longan-shaped-skulled ones, swirling blind, taking in wisps of smoke, and aroma of wheat

Then dissolved into differentiated data. Appearing like a rolling date code stamp,

They formed digits of various numerals, with inherent DNA fragments within,

Snaky bones (almost phenomenal), and got the label

"Superposed State." Braided into a binary plait

Thin and diaphanous, suspended vertically,
They bided their time. Later claimed to be shaped like spinning tops
Instead of coins with heads and tails. They disentangled themselves
Into different positions. This time they were observed

On a two-dimensioned basis. Honeycomb pattern in the bull's-eye
—men in [equilibrium state]
9 Points—men in [particular states]
7 & 8 Points—men barely classed as [existing]
2 to 6 Points—all men known to us.

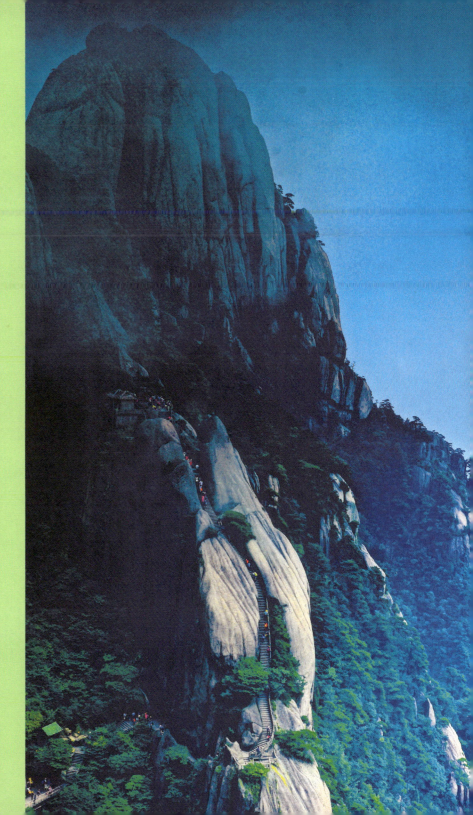

CIRCATIDAL RHYTHMUS

Blustering trees fell inward (all in the shape of a circle, before the Wheel of Fortune), finally giving in

and leaving the boundless sapphire ocean to monsoons, which used to gnaw away

chicories and cypress cones, with its icy fangs. You should pay attention to guidelines detailed in that manual

That the sun's berthing impact on the earth's shore, always so strong

whips everything that gets in its way—So never throw open your curtains

On a summer morn. Just wait: sunlight will climb along a shishi-odoshi

named "the Scale of Everything" …

Once the hollow tube is filled, and center of gravity goes beyond the pivot of a day,

It declines. No need to worry, the bells have their own rhythms to toll

through the dusk, when monks in ochre stroll across

To a stone arch. That is no peak time period for the world

in birth rate or death rate, but it peaks for champagne activity,

and language saturation. The high lightness of humankind's brain zones

Soars, and in the next second plunges. In the light of universe's torch

on its last beach named "the world," all dead crabs lie transparent and feathery, while the living ones of its kind

Synchronize their watches, with the moon.

LOUIS PASTEUR AND DEXTROTARTARIC ACID, 1848

On a grayish slide under the microscope, tiny human figures

evolve into kaleidoscopic anaerobes. Make sure chubby silkworms and ferocious hounds

are in their places, since your being in love with *cerevisiaes'* tribe

has hit the headlines. When wars and misfortunes swept out everything on flights of

World's stairs, how could you trust milk and water

so fickle and suspicious? Benevolent eyes through the dust and smoke sought for scavengers

to clear rotten leaves from veins of human at the cost of

heat and time. Maybe he just overdid it, otherwise, why with their last breath

they praised the land and flocks on it? "Stonehenge is a symbol of

constant state." Tartaric acid crystals, blossom into patina green

In Val de Loire. Across the fingers of the Creator

L-tartaric Acid and D-tartaric Acid, swirl like oil of science poured on the flame

of nature. Daylight is restored, as if

never been stolen. It can be heard, the gurgle of little souls

within bodies of fowls—they no longer swarm into Eden

To be bowerbirds.

BLOOD SERUM, -37°C

A vinyl record and a blood centrifuge machine, rotating in the same way, made the world

as bustling as a casino. Red dices, white dices,

all roll in the rhythm of Symphony No. 9. There are parched, cracked tenements of clay,

And balmy, smooth ones of tallow. On the seesaw of natural cycle

neither is always predominated. Time is dislocated occasionally, but will last anyway

till nothing but white is left. No more blood stain in the ward,

Sheets and walls so clear, almost indistinguishable from the sky above. The serpent rolling up into a ball when it came

went away hanging around someone's neck, turning itself from shackles

to a crown. "It's our warm-blooded brother now,

While its venom remains." "I'd rather if it

had left me a tattoo-shaped scar." Seven thousand voices foaming up

And then drifted away. Your savior, perching in the pale yellow tube.

Sometimes rises like an old wise man, drawing his long white beard behind him

To check out shimmers on this magical liquid, and sits back

Before being noticed.

GENERATION-SKIPPING TRAITS

Move away rosebushes, pebble pavements, and fluttering birds from the shadows

underneath the steeples—the route of the sun should be

kept clear, so rays of light could remain as spotless as violin strings

At the fair, you captured a misty perfume on your nose—the harbinger

of a somber day. "Aren't you the lady from the epic

who talks to the gods as a peer?" for the 1001st time

you tried to explain: that wasn't you, but your grandmother

or great grandmother. But the hands of the suppliant were trembling so desperate, wrapped beneath her dark blue shawl

During sleepless nights, a giant goose crucified under the roof

materialized out of the invisible, its blood trail, spectacular and sinuous, leads into

depth of the fog … Somewhere upstream, there must be marks

left by a ferryman. Fragments of words—"azure-eyed," "aloof," "magnanimous," "hallucinatory,"

even "superphysical" … they roll out of a shattered bottle,

And got lost in the crowds. In the past five hundred years

They have returned to your family like doves that never stray. Last missing piece

lies in your hands now. If you turn around

you will see a halo around her head

MONASCUS RED, ROSA LAEVIGATA MICHAUX BROWN

Zhu[1] and Xun[2]—symbols of the wind and the earth … Over the night-veiled mountain ridges

Dye jars lined up like pipes of a syrinx. There contained in them

were ashes to decorate a monochrome world: garish fungi growing in the sun's shade

and gristles of a rose haw. Crushed, once they were, frothed along the roads

which emperors, sages, and court chroniclers have stridden along, and left

A layer of rusty green—

Beneath the window, on the sushi-rolling mats[3]

glutinous rice awaits its change …

The ethereal woman with a cattail fan in her hand,

owns a room in the background—it is shadowy, almost invisible to Time. Pink oval yeast

is perfect icing sugar for this world—like fallen cherry petals. Gradually they will get tinted by the warmth and voices

of passers-by. Alas! Light and colors started to

drift west now: dress up, cleanse your hands, burn incense and sing a canticle, as the beginning of a worship ritual:

Red: the Three-Legged Crow, lightning flames, and exotic flowers on a thousand-year-old tree;

Brown: soy source, tombs, and earthenware

They plan to return to the future with them. They also carry

The fire bloodlines farm implements sets of bronze teeth …

There are a profusion of antique fibers to chew

1: The Zhu (筑; pinyin: zhù) was a percussion instrument used in the Confucian court ritual music of ancient China. It consisted of a wooden box (which was often painted red or otherwise decorated) that tapered from the top to the bottom, and was played by grasping a vertical wooden stick and striking it on the bottom face. The instrument was used to mark the beginning of music in the ancient ritual music of China, called yayue.

2: The Xun is one of the oldest musical instruments in China, with a history of approximately 7,000 years. The earliest xun was made of stone or bones, but later it became earthen. It is an egg-shaped wind instrument. Initially it had only one hole, but afterwards it gained more holes. Finally at the end of the third century BC a six-holed model appeared.

3: Sushi rolling mat: Proper equipment for sushi making includes short-grain sushi rice, a sharp knife and a bamboo sushi mat. Constructed of thin strips of bamboo loosely bound to make a flat, rectangular, but flexible surface, sushi mats help tightly roll together the seaweed, sticky rice, and fillings to create a sushi roll.

TYPE AB

All vicissitudes actually happened within a (fortissimo) flick of a switch, where Landsteiner

had made a brief stop, lands subsided as riverbeds, and canopies of banyan trees

spread out above the surface of the water. Two doves, one vermilion and one ivory

symbolized the sun and the moon with wings—This was a prelude to the epic of a river

which the fisherman always knew better

"Everything in the universe is in the shape of twisted double strands, one dominant and the other recessive."

But where are the smoldering coals? Hidden in the red pimpernel braids

Disguised as human veins. They salute one another, without ever seeing through

The family emblem on his mantle, capturing a scorpion-shaped shadow

In his throbbing heart … The heraldic meaning of blood types is in

What they describe literally only: Bare your wrist, NOT your chest

He is to draw a conclusion, the man who put everything in the universe

Into archives: the 3rd kind of index after gender and race

"The personality of A2 can be …" You do not actually know what you were arguing about

In the windy, neon-soaked streets. "I'm Type B too." It turned out that you had found a backup vessel

for your soul. Who is the Type AB guy among you? The universal recipient

of all joys and sorrows? There is a librarian, who has remained silent all day long,

His hands are now storming through piles of books on the desk: aesthetics, philosophy, literature, and mathematics …

When you paddle across to the other side, he collects all your relics

SCHWANN CELLS

An insect: never wanna risk my life to fly over

that fluorescent anemone-shaped net, emerging out of a bleak paleness. (THAT is the nervous system of a human being)

The spider: I'll return at dawn, when dreams and flasks of absinthe

are locked behind a wooden cupboard door, and I'll sweep away the remnant of

a night of bacchanalian revelry. (The sea covers the entire mind of a man during nights,

so when a ray of light kindles the daybreak, all waves yield underneath hems of the sky)

A good thought flashes by—it is hyacinth blue; an evil thought flits past—oriole orange.

Yet most of the time there are just distracting grey thoughts: the gossamer of capillary currents, flowing through pearly soft metal

Some grow brighter and brighter, flickering, others dive deep into the cortex

and never show up again. "Short-circuiting is inevitable—just like seawater gushing into the cabin

and makes the ship list. Then an emanation of ephemeral mirages,

tempting deliriums, and disillusioned passions, rises overhead … He starts to gasp with gills

like some aquatic invertebrate." The skin that spider has shed lies there

in the corner of the fences. Obviously no lost hiker will pass by today.

The woman spinning in his head is as brilliant as light itself, and 100% active

But it is no more than a holographic image: purified, processed and revised by his will and passion …

Everyone has his own wasteland, ever stretching without overlapping, like an archipelago scattered in the air

BROODING OVER THE DWINDLING FIGURE OF A KENAI PENINSULA WOLF

To slit open the glow-suffused canopy above, you must turn around first

and face the grey and damp vastness. In the heather shrubs lies the Excalibur of the mighty

resplendent with a diamond in its handle. Your hands are stuck, there between

maxillary and mandible jaws of a Kenai Peninsula Wolf. One possibility of geological history must succumb to another

that seems more likely to stretch permanently. You used to witness whiteness extracted

from wheat and milk, and tapped with mallets to make it chewier

"Get me stoned, or turn me into a stone."

—In return he murmurs Lamentations

into your ears. Soon you will be banished into the darkness

of a hangover or a crush.

But what are you, precisely? A musk ox?

A link in their concentric defensive formation? Or are you a blessed infant,

Or some ardent, self-sacrificing devotee? The scavengers on the hillside

have drawn second hands from clocks for the fencing:

In the capricious world, a belle is now Bodhisattva, now asura.

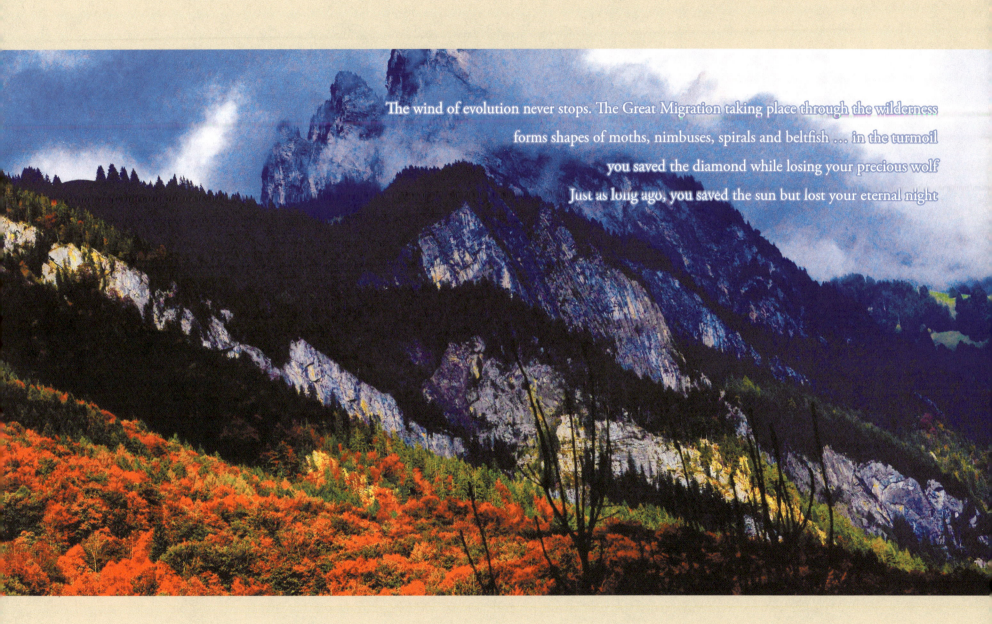

The wind of evolution never stops. The Great Migration taking place through the wilderness

forms shapes of moths, nimbuses, spirals and beltfish … in the turmoil

you saved the diamond while losing your precious wolf

Just as long ago, you saved the sun but lost your eternal night

53

FAMILY FEUD OR COEVOLUTION

It springs from remote antiquity and sweeps through to future ages:

What was once between oceans and fresh continental shelves,

Nautiluses and sea scorpions,

Also, catfish and their "feathered prey"—the pigeons;

Now it flows between the inferno and a decadent, on whose mind moodiness lingers on

Every legend off in the wind is but about you and the "her." Like what the blacksmith shouted: "Sharpen thy canine teeth!

Tear apart thy foe, or thy owneth sanity!"

Slow down, you said, the distance between us is way larger than equilibrium, the dust—harbinger of fate

has foreboded the thorough downfall of food chains. He to whom caves and grasslands belong

will eventually be left forlorn and defenseless;

Hurry up, this time you said otherwise, God is standing there in a pool of shimmering light, just among us

He endowed me with golden horns and hoofs, as if labeling me as inedible.

A hummingbird snuggles its head in a pineapple flower, like a beauty sits

in a haute couture dress, and grieves ceremoniously

—You never know, whether the bloodthirsty fangs

of the "she" of yours, fit your throat. It will not be today, though,

There is still time left … at this moment there is even a smiling air around her, reflected on her picturesque features

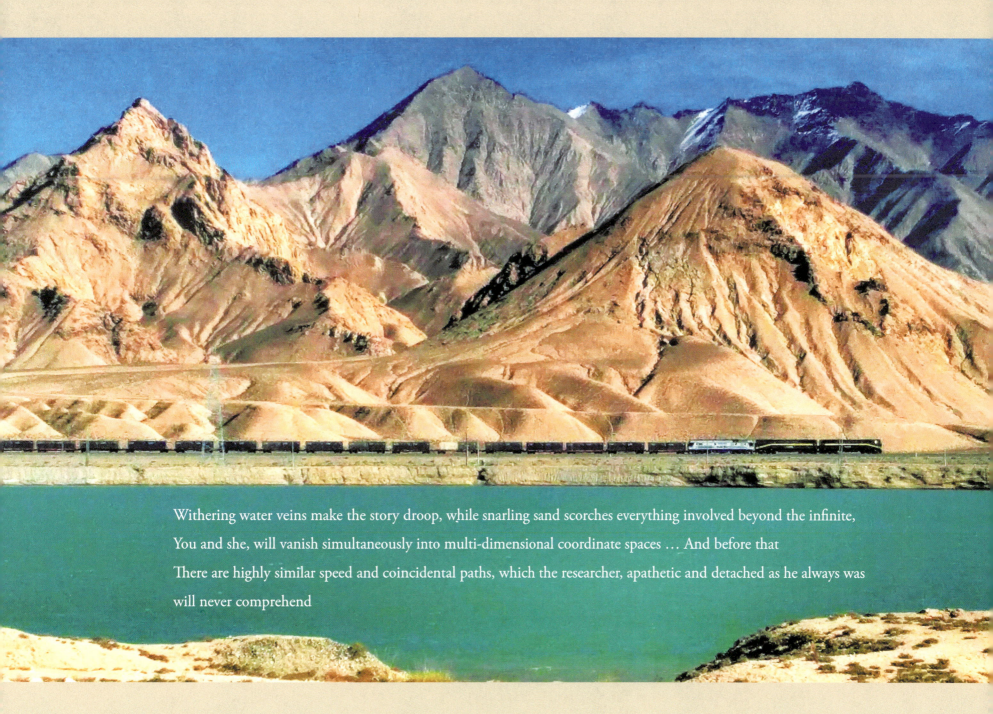

Withering water veins make the story droop, while snarling sand scorches everything involved beyond the infinite,

You and she, will vanish simultaneously into multi-dimensional coordinate spaces … And before that

There are highly similar speed and coincidental paths, which the researcher, apathetic and detached as he always was

will never comprehend

BEE VENOM, THE THOR AMONG MEDICINES

Never simulate vodka distilling by making reservoirs of your joints

Just watch how haystacks lean towards a storm, how cassava roots chime like bronze bells

When joints are puffed, they are just like candles afloat on the rivers—

A voice from above thunders:

Human minds are similar to that of camels, but they never manage to consume the water they've stored up

When crystal deluges overflow interwoven rivers inside, crusts of them melt,

and they have to move to a darker shade on the grayscale chart

"Liquors are combustible." The smart alec doctor said, "Once the flames begin to billow

Hurrah—the sky clears up, all of a sudden! Now, pass me the lighter!"

A new crop of marigolds blooms, between his forceps: they peck you hard in the joints

When you listen to rolling thunder and whining wind outside, the lamp vibrates like a metronome

Dogs are searching for signs of life. His woolen mittens and helmet

have been found. He is right here standing in the building, emitting greenish fluorescence

Only twenty yards away from the crowd, yet beyond their feeble perceivability

"Look this way!" Ruins are everywhere, disguised as gardens

A debt to God is always with high rate of interest—He is the only one who can see the man

See his brand-new golden blood and its mauve glow

There will be another lonesome vessel left on the beach

when everything else ebbs away

COMMUNICATION BEHAVIORS

With scents of walnut and saffron oil, the skeleton of his life is now pegged

out on the line. The curly fringe was taken away, half rack of ribs removed,

and thumbtack holes are exposed, which look rusty against the dim twilight.

Balsam firs burning in the autumn winds—symbols of the deceased;

Howling gibbons and running wolves—of the advanced;

Frills cracking and falling from the sun—of the decrepit;

Coal particles shedding from the golden clouds—of the deranged …

Code segments are long and usually places broken lines,

that usually turn into laminar flow in the labyrinth of the ear.

A telegraph keeps clicking, while nobody is sitting around.

The iridescent plumage of the season has been ruffled up,

so the sorcerer can dance, murmuring incantations,

with plumes around his knees, and on the backs of his hands.

—Turn the corner and you would see a new spring coming

There is a cheetah, which has ambled along the front of night,

and picked up the setting sun from among the tumbleweeds.

There is energy
lingering out here,
still powerful enough to hurt,
using a mysterious lip language
of dying fish.

61

THE PINEAL BODY—THE 3RD EYE, DEGENERATED

Tumbling through frontal clouds and tangential winds, the eyes turned

from jade green to rosewood, like a pair of lobsters

"For the following years they will just prey on shades of its earlier scent,

And grow numb and chalky …"

Ecstasy and beatitude bubbled in the light, and trickled down every still, cold object:

Vases, watches, and silverware …

The clawed fools took it for tangerine jam

They sniffed near the shrine, and captured only the fragrance of basil leaves

enclosed in the letter you sent to God when you were a juvenile

People with shackles sat in the dark, knee-deep in the chilly water

The wise old said "The water originates inside your mind; it's called 'melatonin'."

When light veiled itself, you lowered your hands—puppets of your dancing and flirting

"Sentenced to sleep, effective immediately." The world breathed smoothly ever since, with noctilucent clouds half-fermented

It deflates when light inflates; it rises when light sinks; the universe is a system

Of two balloons, tied together, mouth to mouth

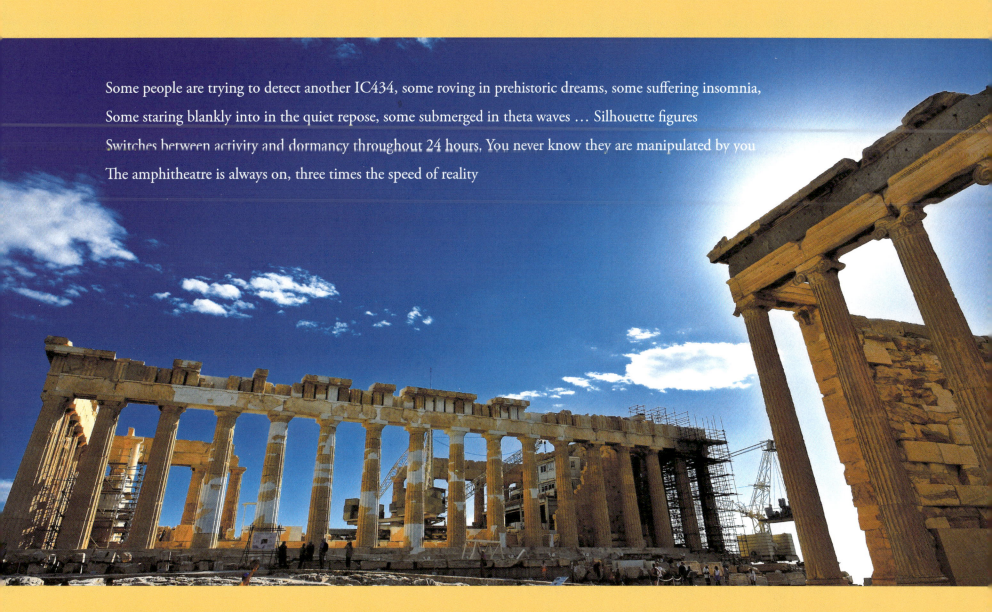

Some people are trying to detect another IC434, some roving in prehistoric dreams, some suffering insomnia,

Some staring blankly into in the quiet repose, some submerged in theta waves … Silhouette figures

Switches between activity and dormancy throughout 24 hours, You never know they are manipulated by you

The amphitheatre is always on, three times the speed of reality

ALLELES: DIVINITY AND THE ID

The relative positions of the lamp and the wall, are more than subtle. You have kept it secret

that when the lamp is on, the woodpecker hole on the wall disappears—

like ripples wiped off from the surface of a lake

Your have a lot hidden in there: paradoxical stories, open-ended questions,

warm lies, and the possibility of serendipity,

It is a karst cave to you—narrow opening, marvelous volume.

Unfortunately, it is actually a dent, made fortuitously by the force of weather, while rampaging its way through

Therefore too shallow, to hold those dark wishes against God

The other self, which diverged from you 30 thousand years ago

drifts swiftly past your door. He belongs to another phylum,

of course another class, but when you give each other a high-five

You find your hands cast in the same mold, one golden, the other black

The flooding illumination from the east swallows the velvet murk in the west …

—that ritual repeats itself every single day. It is so irrefutable:

Transparency is the darkest shade of every color, it covers all up

with consummate ease

THE ORIGIN OF SPECIES

The coagulation of mass makes silhouette of a hippo, though each of its pieces as light as a treehopper

"*le Londomain*"—a colossal ship, whose proportion of hull above water varies from time to time

barely keeps from sinking—but details of cholesterol increase,

Vitamin C deficiency or body fat percentage fluctuation, are nowhere in the log to be tracked …

The ship name is a jigsaw made up of sharksuckers, tinier sharksuckers, and digits even tinier

Digits of smaller binary sequences … Crisp, and undivided at last

Just like Darwin's dotted line course, from Cape Verde to Tierra del Fuego,

during which ptarmigans had molted twice and thrice again.

Scattered in the virgin snow, were days and nights sloughed off

There is an unwritten code: as soon as it arrives at a port, an exchange transfusion begins.

A wooden-faced mathematician has deduced that

When the ship reaches its final destination, there will be nothing as old as the sailing day left aboard

That is why he weeps, standing alone by the gunwale. But when the sadness transfers from his left cheek to right, it turns into joy

Before the next day, he will have completely forgotten his former self

A NEIGHBORHOOD OF M'S AND N'S, IN THE PERIODIC TABLE

You have problems explaining your situation, that the Laputa you live in

is a remnant of some honeycomb. It came from outer space, sleeted through the polar atmosphere

with positive & negative electric charges, and landed in a remote antiquity so primitive and desolate

In the hexagonal wax cells a scintillation was born, with patina and sharp edges.

You squinted your eyes against

the glare of the sun and decided: "go east!" Metal probes stretched out from your pupils

detached themselves, and flew over polar terrains

north of 70N. Yet the brilliance faded away halfway, while spectacular landforms below

were unveiled, from beneath the mist. Not a note of a saxophone ever reached the other shore …

Your nearest neighbors are golden furred foxes, in contrast of which, the bulky ones stumped about

With salt-like rock powder on their shoulders.

To sail across the Mediterranean of metals, you must be as slim as a surfboard

and have feet strong enough to glide through the wind. But first of all, you should appease the radioactive

and leave a buffer zone between you and the spontaneously combustible

before you travel seven thousand miles, to knock at

the doors of Al and Mg. During those years, they have grown further and further apart
like the sun against the moon. One vivid and radiant, the other velvety and lambent
both covered with pollen. When they were born, they were once so much alike
pure and epicene

CONJUGATED EFFECT

You are not much of a sharer, especially when it comes to your geothermal power,

Ultraviolet light, and the butterfly-shaped ozonosphere. Even so, you have lent to your brother

A hand and a foot, even the sidewall of your magnificent palace

as well, and thereby those of his become available to you

concurrently. Like gods of the primitive, four hands and four feet

diamond-lustered twin stars, swirl around your common barycenter

night and day. When you flush, your crusts turn into a garnet hue

So bewitching: your marvellousness, his luxuriance. When you slip your right palm

against his left, the ultimate perfection of energy is reached, and a torrential burst of light

surges east. The hexagon you have shared is a subterranean lake

in the depth of oblivion—it contains the only weak link

of your invulnerability. "With its silver shine, you see through the internal of each other …"

Do squander his effulgence, and tamper with his satellites!

Bait the celestial bodies and nebulas lost in space

They will gather around and devote all their faint halos to you

"Before tomorrow, all of you will have joined up as an aromatic ring."

That is your only will

And the only thing that rests them in peace

THE GROUP 0 ELEMENTS

A guy walked by but no footsteps were heard. It could be on any dusk

You sat in the community garden

wrapped in a shabby grey blanket, disguised as a blind man—thronging feet sparkled on your eardrums

like flowers on a Chinese perfume tree, rising from the surface of

mirror-smooth pavements. Chalky-white face, luscious lips, folded arms …

all those seem more like personal symbols. A splash! That's the sound of October pigeons

landing on the streets. Yesterday, the black-and-white photo

of a violinist who used to frequent here

appeared for the last time in the newspaper—among obituary notices.

And all of you started to change your umbrellas and locks this morning,

neglecting rays of the sun, which ran by in black nylon shafts

like small beasts of prey. You caught a glimpse of the construction crew,

busy repairing the bridge guardrails. The cordon they had drawn looked like a roll of film

"On duty today?" You talked to him when you passed by

He turned around and looked right into your eyes, startled and somewhat upset

Under the V-neck of his baseball jacket, a silver chain
dangled across. The fact was: He seldom communicated,
or trusted … He just walked away, with his brothers, all in different directions,
like a hardcore band, splitting up

CARBON-14, THE UNYIELDING DRIFTERS

"Oh là là, Nice pearly aura today!" "I can see that! Why are you still alight,

old chap? How long has it been? Eighty years? We were, you know, just like fluorescent jellyfish

carried by ocean currents."

Over the night-shrouded wasteland echo the rustling voices…

Their owners cleanse the matrix of pores on their skin, everyday, with soap and spring water

in case they get blocked and the rays within smothered

A diminuendo of visible light, is the presage of a devastating storm

The ox flattening itself on the hillside, is running out of its flames of life

Before tomorrow, it outline against the horizon will be truncated

by scavengers, and sink deep into the yellow soil

How bones resemble sweet olives! On sunny days centuries later,

pottery jars unearthed will swirl on the rocks, like revived albatrosses do,

spreading their wings, thin and covered

by volcanic ash. Curves of the earth run in all directions

but all finally into the infinity of darkness. On the mountains, in the basins and along the coastlines

the ants cluster and disperse like shifting sand, or puffs of cloud

raised by the west wind

THE CO-QUETTE IN BLUE

Being asked (for the third time) about his reason for planting a dove tree seedling

in a luminous cup, he kept on meditating in a detached melancholy: there is no seedling

but shreds of moonlight on a stem, soaked in the blue shimmers of cobalt

Drawn out as a new pole, out of night's sheath—

Beneath which, molten parts of the sun chilled and became

A layer of enamel to paint on. Autumn winds swam southwards underwater all in a shoal

through their fingers. In a transiency of switching warmness and coldness,

they wrote down in shorthand revelations of water, in what they called Голуоеп

When a levitated locomotive whistles past with bubbles, the scribbles

started to stream like ribbons do … Magnetism within him, as if growing inside scallop shells

can be decrypted by a stylus, one day, into annual rings

—The relationship between magnet and blue, was identical with that

between a cheetah and a gazelle. He found himself suspended from the dome of a cathedral

with starlight trickling down his heels, like some minty stain.

That was the source of the blue in people's eyes

that will emerge tomorrow.

TWO DAYS AND TWO NIGHTS OF MELEZITOSE

Among the windfalls pitter-pattering on the window, you heard the names of Fructose,

α-trehalose and Laminaribiose raining down

"A castle on a winter night" is a synonym for "prison," where all withered colors

are revived on his merciful canvas. How exquisite his blind eyes are!

There were malachite paper flowers blooming in his eyes! Their shimmers rolled slowly down

into the open clearing, gleaming, reflecting the hue of honey on his painting brush.

Like a drop of lemon yellow, with which rape flowers and dwarf umbrella trees had been stippled.

Smooth it out, like what you had done to a lily-white sheet of paper. You can plant the worn brushes in the plain

where they, redolent of oak-like scent, will repel

crows and jackals for you. On the first day, a girl in canary dress

irrigated your flowers with paint, and drummed the empty bucket for victory. You still have time

to tie your silver hair to larches and Douglas firs

all over the mountains. You failed to foresee what would happen the following day,

But later they told you about a grand painting and the mellowness of that era.

When doves returned to the riverside, your wounds from being stripped from the trees

had long been healed.

WOLFRAM

"Optics is the philosophy of extracting daylight from night." In the eternal gloominess

after the withering of a candle, at last he lifted his hands

so dusty with silver grey. People flocked to the pile of ore

he had dug out. "We make a lock out of it,

so daylight will evaporate no more!" Wolfram remained imperturbable

in a Petri dish, shimmering like an unfolding lotus

rising from sacred relics. He looked outside: the earth had been divided into two

by light and shadow. The Old World

in gauzy pink dusk, while oceans in the New World were surging over

a crescent horizon. Once inside the lock cylinder

restless sounds converted into tranquility, spheres of tungsten wires sank and floated up

in branches of the river of night, purged itself of dross

and shone. "Sleep now! The flames on the eastern ranges

will quench it, with more heat and light!" They fell asleep with prayers or totems, none of whom rose early the next day

to witness this reunion. Wolfram,

a blind saint, wrapped in rays of light

without knowing it, walked past the cliffs,

bumped into the sun

but walked again through it, like what he did

back in savage times, he hesitated a moment

wondering what it was,

that he was brushing elbows with

ALLOTROPES

You met him once, when the galaxy was in flood

and waves of astral particles surged forwards, and vanished along scintillant aesthetic orbits

He seemed just ordinary against blank photo noise, like a silver spot

flickering across the vastness. The only thing

that distinguished him from others, was the sorrow that betrayed him

when he gazed deep into the glacial space. Today a buttery-coated rodent

nibbled away buds of your last wild rose, high on the bleak mountains.

You drew your sword. It rose and turned back and …—it was he!

"Without the roses to refuel with, I will soon die." "So you've been

trying to get blood from a stone? All your breed needs is cress, or just thyme."

The shadows falling petals cast on his wrists, covered up its paleness

like blazing parches. "Let me trigger your decomposition …" under the spell of

your combustion spoon and cherry reagent, he bloomed in front of you

into an enchanting array of fragments. You saw through his vascular bundles—

the same blue blood as yours. On this planet you had never seen those rare elements

in another being … "Now close up! Let's share the fuel, buddy!" Unfortunately, this time

he had not received your message. In the wind, pieces of him danced into

your rose furnace, and melted like ice

rather swiftly

A POST-PRODUCER AND HAWTHORN-ADDICT

(C11, M54, Y89, K0): the daintily-mellowed tints of a glorious sunset

Glides along his vernier of Color Depths

C—a positive value indicates: African blue basil; and a negative one: tulips bulbs

M—positive: saffron flowers; negative: red cedar wood

Y—positive: curry powder; negative: lavender

K—positive: black cardamoms; negative: white peppers

(How the spicily fragrant colors have absorbed the essence of the world around him!

The hawthorn underneath his tongue tastes as insipid as a mothball now)

The dwindling form of a lady vanishes beyond wind-etched grooves and mushroom rocks …

He yearns so, to affix a pair of wings on her, with some sealing wax.

(Or to replace the color of her windbreaker with scarlet? Which the chief editor has strictly forbidden—

Art, love, whatever his excuse might be)

And to give her a twilight tint with the "soft light" blend mode

All begins with the color of a Jericho rose

And ends somewhere dim and undiscovered

When tranquil beams of an afterglow carved everything out

What's left for him to do is to brush away the wood dust

COASTAL EROSION

Aperture F/11.0 Focal Length 24 mm ISO/Film 100 …

Scribbled and crumpled, thrown into a waste basket, the labels were still bouncing.

Out there, from the pictures in the exhibition hall,

Images of flamingoes buoying up, formed embryonic brilliance of the dawn,

There was a metamorphosis, taking place simultaneously, inside and outside

"Thanks to my photographer vest and winter coat!

I could hear them lashed and battered by fogs, sea gusts, and blizzards …

They have endured the abrasion for me!"

His hands are a duplicate of his face, coconut brown and mischievously wrinkled

Never lies the mirror when he looks down at his counterpart within—

Simmering tides laced in by the coast,

Flap against the sea arches.

Several crops of jackfruits

to be reaped within the frame …

and the petal—feathered seagulls,

Kept surging out. They had struck

roots in his four-headed muscle,

With webs spread out. A hollow

appeared between his ribs,

So a white bird successfully brought him

down, when it rushed into it, impulsively

"He has indulged in the charm of vicissitudes,

Until eventually overwhelmed."

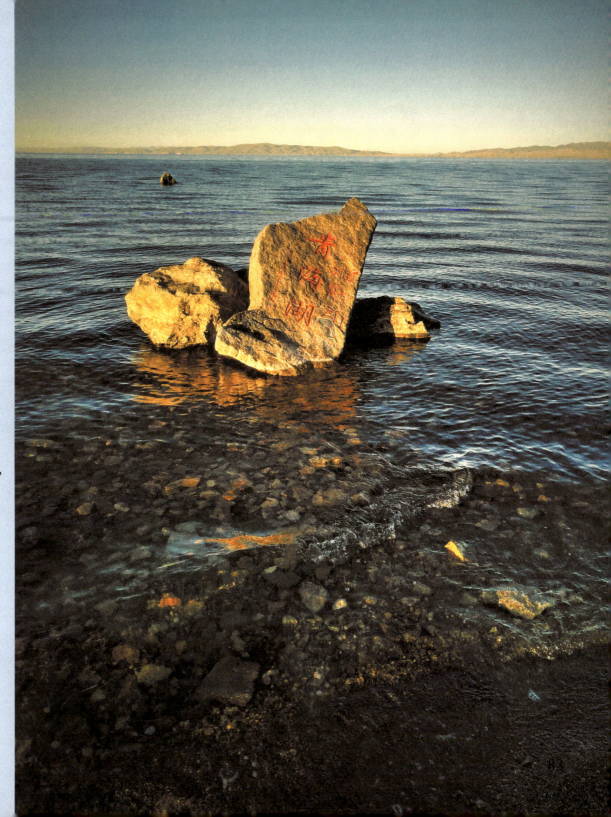

WHIRLPOOLS WITHIN LOW KEY SHOTS

Exclusive recipe for "BRONZE": a dipsomaniac kookaburra + a bloodthirsty bat

+ wastelands, lagoons, and mountain ranges: 30 mg metallic luster was thus produced

(Canned for future use. Silk draperies were prepared too)

A low-angle shot: focus on her dark-moon eyes, to measure light …

Objects around: a straight back chair, a black cat—in the deep shadow of the archway,

Silver ornaments, dead insects haphazardly strewn,

Swirling, camera-dodging skirts, medieval rivers, and whispering breaths

Light source—the mighty agitator, rustled through the air

Where are your sandpapers? Polish this prickly canvas

And gloss of the second season is all unveiled now: but one of the objects in this still life,

Has murdered the light.

In this abrupt, bottomless darkness,

Her hand, which raised you from the ground,

was captured by the wide-awake lens too (you haven't even laid eyes on that snapshot ever)

GREGORIAN equals 'rosy fingers' plus 'withering flowers'

LACRIMOSA equals 'pale fingers' plus 'thriving flowers'

RADIAL PHOTOGRAPHY, HUMAN-CENTERED

You never exerted gravity, the way neutron stars do, so why are all celestial objects attracted to you

Forming an equiangular spiral, like crested ibises underneath draperies of the dusk (the glistening tracks are not detailed in this shot

But an inevitable storm is brewing from their roots) all stars are hanging there in the shade

All rivers honor you as their very first explorer

There were ropes, invisible beyond the clouds: tightening up, driving them inwards

From chaos into sequences, from sequences to a singular point—

As if they were shoals charmed by sound waves: light and energy are converging on the edge. While within the circle,

The closer to the head of the rope, the larger holes there are, dispersed into space

"Scenes of high density, die almost exclusively on the skyline/horizon

Or among sinned humankind." Forests, cobwebs, winding stairs, prayer flags ...

(You are as smooth and as serene as a spinning cloisonné vase.

Now light is chiseling cocoons of everything, from which giant mirages will emerge)

Whatever will come will be lodged among us: your features imitated, your tempo followed,

Your irises duplicated, just as in the eyes of a descendant

STUCK IN MOMENTS, MACRO PHOTOGRAPHY

The indefinable elapse of time consists of numberless single threads of logics:

Vivid blue of multi-petals, flickers rising from sepals …

Within an interval between breaths, nonlinear evolvements have started in the shadow

(A message to you from cells: you are allowed to land here. The leaf veins and green pigments you ever set eyes upon

Are but a tiny reflection of the clouds)

In the dead of the night, light-absorbing coat veiled in dimness,

And rivers melt into milky mist

(The spherical surface that has dispersed into grids, will rejoin into a plane somewhere

While bright-colored, dangerous animals slow down their eye movement

—the fragrance of flowers you once smelled, freezes gradually in the air)

(Time is thinned down into translucent water waves, and plants animalized,

If a small one, among 9 hundred grids, catches fire

The entire picture falls apart)

A mirror image is hidden in droplets, one and no more, stayed there for an instant and no longer

—with a silvery texture and a long finish

BULB PHOTOGRAPHY (SEVEN CAPRICIOUS HOURS)

[Streams]

Just wait for the marshmallow to melt …

Foggy murmurs, derive from retrograde of its shimmering fibers

While gutted and cleansed body of water, suede-soft, close to 0°C, is frothing lilac silk

(Waves have been appeased by time itself. Soaked evenly in pearly luster, it becomes a jelly where algae are locked in)

[Expose the streams to light now]

They MIX. The coloration of liquids is a process with heat release

Dye the haze and make it full-bodied, somewhat satiny

And a little more showy and sensual. Here are cyan and royal green …

Neon-lit switchback roads running zigzag afar—

They have formed the leaf veins of earth

(Maybe you were seeking for streaks of meteors or fireworks at first)

[Wash out all but light within one certain speed interval]

Sweep off those shadows passing by so swift, those bouncing, twirling, shifting ones …

Abandon the habit of haste. Those words, when you heard them, were right there in the wind, tinkling

Like a mouthful of smoke lingering around. Before you remember to stop for the latter half of the sentence

You have stepped out of bounds.

REMBRANDT LIGHTING OR BUTTERFLY LIGHTING

"The ferret dwells alone in deep snow, with egg whites of night clinging to its body

There drifts its extraordinary odor, still interwoven with fugitive shadows—

As if just born from some gilled creature"

—comments on "No.1, Rembrandt Lighting Series"

"The Creator pours LIFE into a spindle underneath,

So a trickle of it could roll down—into her cranial cavity, which was a karst cave in fact

From every cocoon emerges a moth, or a butterfly: just like the one, vivid black under her nose

It seems a spirit while she a shell; it a fluid while she a solid object"

—comments on "No. X, Butterfly Lighting Series"

Crowds swarmed in … Pages of brochures were skimmed through: a cover in black and white;

A flap in black and white—but ornamented with occasional leopard and laces

They walked across the gravitational field, and distributed light for him:

Edge lighting for the windbreaker lady;

Split lighting for the urbane young scholar; loop lighting for the female reporter …

The studio is but a field of vanity

Headline tomorrow: MIXED REVIEWS FOR THE PHOTOGRAPHER

He will be leaning back against a stone in his limestone grave: immersed in the grotesque lighting in there

And 20 grams of floral bath salt

FORCED PERSPECTIVE

You stated

That landscapes on postcard and plates

Are lithographs of their previous incarnations

Antique, delicately yellowed

Never essentially cut off from its environment, when fitted back—a seamless artwork is restored

The old lady with gold-rimmed glasses interrupted you:

Gloves off! Show due respect to the judgment!

Gloves? Yes you have borrowed them (with a pair of wrists) from a magazine cover

Close inspection shows a subtle distinction—your mahogany skin

In contrast with his beeswax hue

He has piano-playing fingers, which wither with pages of a musical score

When a storm roars outside. While yours, will unveil themselves at night, like branches of a lightning-stricken tree

Sharp silhouettes against the horizon: rising sun; everything drawing their shadows behind—

All to your charm …

What you just told yourself, will never be used against you in any court

She pointed at the lavishly-framed photograph,
blaming you for looking lofty,
adrift on that grey background
It tinkled you right:
The enormous grey in there was the ground,
and you were just lying tight
Pretending to be wrestling with gravity

91

ARMCHAIRS? CRINOLINE DRESSES? THIS IS CALLED ART PHOTOGRAPHY

This Agreement is being signed by and between the Photographer (who proclaims himself an oil painter),

hereinafter referred to as "the PHOTOGRAPHER" and the client (his model as well), hereinafter referred to as "the CLIENT."

The CLIENT and the PHOTOGRAPHER agree that ancillary facilities are essential

to accomplish the goals and wishes of all parties: "*Scuola di Atene*" costumes, 18th century wigs, crimson draperies,

The carpet (underneath which 21st century white-ants dwell),

A bouquet of roses, snowdrops, van Gogh-esque irises, red daisies, several antique vases, a bunch of grapes

If the CLIENT shows signs of astonishment, alarm, or even panic after the first flash,

And takes refuge in the dressing room, the PHOTOGRAPHER will be awarded 1 additional point

(e.g. "What was that? I just got stung in the eyes … I'm bat-blind now!"

"A survival from Eugène Delacroix, I mean the composition Style, isn't it?"

If misunderstandings happen on delivery of the final products, 1 additional point to the PHOTOGRAPHER

(e.g. "There must be some mistake! I'm not an art collector!"

If family members of the CLIENT, unaware of the photograph-taking project beforehand,

shows admiration to grace and beauty of his/her bloodline, (esp. bringing up the topic of age), 2 points to the PHOTOGRAPHER

(e.g. "Oh your grandma looked so much younger than you are!"

"This is the most expensive mirror I've ever bought! A mirror of delicacy and elegance! Could you take this as frame of reference?"

If in the first three months after project closure,

the CLIENT shows greater interest in *Le Retour de Martin Guerre* or Tulip Fever than Star Trek, 3 points to the PHOTOGRAPHER

If the first thing the CLIENT does to new jams, syrups, and whipped cream is

add a touch of them on the wrist, instead of tasting them, 3 points to the PHOTOGRAPHER

("Wait, it's the same color as my Victorian armchair! What a shame the back of my hands got much tougher …

why are you in such a hurry?")

This agreement is made in ONE original that should be held by the PHOTOGRAPHER.

It shall be valid and remain in force for the rest of lives of both parties from the Date of Effectiveness.

The PHOTOGRAPHER shall not be responsible for Classicist Sequela of the CLIENT.

Disclosure of any part of the agreement to a fourth party is strictly forbidden (the 3rd party=the CREATOR).

A SURREALISTIC PAGE IS THERE, CONCEALED IN EVERYONE'S MIND

She labeled the floating island as "for rent":

With its lurid surf-shaped flowers, and their weeping ears.

Keeping her distance seemed necessary;

This phantom Laputa, haunts every corner of the block, like an ancient warship sneaking up

Her strongholds, diurnal or nocturnal, were all pushed to the world's end

Below her feet, cave-riddled escarpments and shoaly valleys

Camouflage the entrance to Inferno

A hundred thousand ways to awaken herself: A stinging slap, some cold water, a pang of pain

Or just autosuggestion: out there is nothing but a broad, mirror-like street

Illusional houses, virtual riverbanks—all are but photomontage works

Giant Shadows are they, cast from inside the empty vessel, where the soul sojourns

But now they are fading away, so feeble and flimsy

"Post process is supposed to be done tonight, our customer wants it tomorrow."

Having reorganized her files, she is ready to leave.

Elevator car, indoor waterfalls, perfumed washbasin

"See you!" she waved to Paul,

Never mentioned his being ram-horned, human-headed, and horse-bodied

Paul knows it all—he was the one that had taken over the floating island,

And saved her from endless entanglement

ABOUT THE AUTHOR

YIN XIAOYUAN (Yīn Xiǎoyuán (殷晓媛) is an avant-garde, crossover epic poet as well as a trans-genre & multilingual writer. She founded the Encyclopedic Poetry School in 2007, initiated the Hermaphroditic Writing Movement, and was the chief drafter of the Declaration of Hermaphroditic Writing. She is the project planner and visual designer of the *Encyclopedic Poetry School A.I. Papercube* (10th Anniversary Special Edition), *PoetryXPhotographyXManuscripts Album* (12th Anniversary Deluxe Edition), *12th Anniversary Commemorative Medallion* and *HeavenXEarthXMan: 2020 Calendar*. She directs the Creative Writing & Integrated Art Workshop, members of which include poets, writers, dramatists, musicians, visual/installation artists, photographers, and calligraphers. She is a member of the Writers' Association of China, the Translators' Association of China, and the Poetry Institute of China.

Her works written in Chinese, English, Japanese, German, and French and translated into Italian and Spanish have been published home and abroad.

She has translated works of over 120 contemporary poets in U.S., U.K., Sweden, Mexico, Ireland, Italy, Spain, Australia, Argentina, Japan, India, Cuba, Chile, Peru, Honduras, Columbia, Bolivia, and Ecuador.

She has travelled around China on her own, especially visiting great mountains including Mount Huang, Mount Hua, Mount Heng (Hunan), and Mount Tai, which she summitted on foot.

T. V. Petrusenko, of the National Library of Russia, referred to the works by Encyclopedic Poetry School as "a new trend of contemporary Chinese poetry," and Glennys Reyes Tapia, of the National Library Pedro Henríquez Ureña of the Dominican Republic, described them as a "bibliographic treasure of their [Chinese] culture."

Xiaoyuan has published 9 books including 4 poetry anthologies: *Ephemeral Memories, Beyond the Tzolk'in, Avant-garde Trilogy, Agent d'ensemencement des nuages*, and a translation of New York poet-artist Bill Wolak's poetry anthology *Become a River* (New Feral, 2018).

Yin Xiaoyuan has written 18 epics (which include a total of 70 thousand lines) and 24 volumes of encyclopedic poems. Her epic poems include:

WIND ROSE SEDECOLOGY
(风能玫瑰十六传奇):

Iki of Bashō, Wabi of Muramasa
(武芭蕉,雌村正)

Seepraland (锡璞拉群岛战纪)

Wind Quencher (止风之心)

Hanoi Tower (汉诺塔)

Turkana (图尔卡纳)

la Byzantine(拜占庭野心)

Doppelganger Duet（自他体二重唱）

Lapland Blood-soaked（血沃拉普兰）

The Space-time Optimization Bureau
(时空优化署)

The Disappearance within Atacama
(盐湖疑踪)

Twin Flames（双生火焰）

AVANT-GARDE TRILOGY
(前沿三部曲):

Nephoreticulum (云心枢)

Polysomnus (多相睡眠)

Enneadimensionnalite (九次元)

LIST OF PHOTOGRAPHS

ABOUT THE ARTISTS

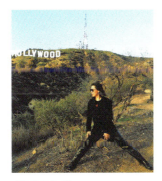

CHEN Shui

Crossover artist/Cultural scholar (China)

DENG Xiang

Poet, Scholar, & Jean Monnet Chair Professor (China)

Ölmalerico

Poet (China)

John Charles RYAN

Postdoctoral Research Fellow in the School of Arts at UNE, botanist, poet, theorist, and ethnographer (Australia)

Jason SHEN

TuneGO / LazyDragonEntertainment, Record Collector, World Traveller (China)

WANG Jun

Poet (China)

XIA Haitao

Poet, essayist, member of Writers' Association of China, senior fellow at Lu Xun Literary Institute [31th], Winner of 8th Bing Xin Prose Award and 27th Sun Li Prose Award (China)

ZHANG Wanchang

Aerospace Information Research Institute, Chinese Academy of Sciences (China)

PRAISE FOR *CLOUD SEEDING AGENT*

"Undeconstructible and enigmatically unyielding," that is Yin Xiaoyuan. Her poetry weathers vain attempts at interpretation and rebukes all efforts at categorization. Her ink blends Catherine-wheel fireworks and hydroelectricity: Awe and Shock. A partisan of the new, so strong and audacious, she unites Octavio Paz and Ezra Pound, rescues Oulipo from its degenerate state, and exposes—bluntly and unapologetically—Beauty and Philosophy running in tandem and chafing against each other. No one can ask a poet—or Poetry—to achieve more.

—George Elliott Clarke
Parliamentary Poet Laureate of Canada
(2016 & 2017)

"无法解构，拒绝媾和。"（《质数颂》）—这便是对于诗人殷晓媛的最佳注解。她的诗歌气象使得一切破译的企图望洋兴叹，一切归类的尝试相形见绌。她是"墨"与"凯瑟琳"[1]的耦合体—轮转烟火[2]与水电能源：令人油然而生敬畏与震撼之感。她是新生事物的坚定同盟，强悍无畏，文风犹如奥克塔维奥·帕斯（Octavio Paz）与埃兹拉·庞德（Ezra Pound）联袂，挽"乌立波"风格于既倒，在率直与毫无愧色的文本间，美学与哲学的马车并驾齐驱，彼此角逐。对于诗人造诣，对于诗歌文本的期待，至此观止。

—[加拿大]乔治·艾略特·克拉克
第七届加拿大国会桂冠诗人（2016-2017）

[1]指殷晓媛邮箱用户名中的两个单词。

[2]轮转烟火，即"凯瑟琳之轮"。在中世纪欧洲，凯瑟琳之轮是常见的纹章图案寓意物，一般被描绘成为插刀的轮子，象征图案持有者对信仰的决心—决心接受任何残酷的试炼。在欧洲凯瑟琳之轮被发展为一种焰火表演，表现为高大烟花架之上旋转燃烧的烟花之轮。

Yin Xiaoyuan holds back nothing. Their poems are bulky, excessive, cinematic and suddenly despondent and pulling back and the poem ends. I applaud the richness of the work, its bravery, its quirkiness. I turn the pages of *Cloud Seeding Agent* eagerly for another vista and another reshuffling of what a poem is. I feel like a fledgling lover, abandoned, happy, and surprised.

—Eileen Myles
Poet, author of *I Must Be Living Twice*

殷晓媛的风格是酣畅淋漓毫无保留的。她的作品体量庞大、穷工极变、银幕感充溢，总在出乎意料之时突然笔锋一转沉入低调或戛然而止—一首诗急势陡收。我不禁为她作品呈现出的丰饶、刚劲与诡谲而喝彩！我热切地翻阅着这部《播云剂》，探寻着关于"诗究竟是什么"的另一片崭新洞天、一轮全新洗牌。我像一个青涩无知的情人，被在这文本抛在背后，欣喜而又诧异不已。

—[美]艾林·迈尔斯
诗人、《我准是活了两次》作者

Yin Xiaoyuan's writing is remarkable. The energy it displays in intellectual conception is compelling. So too is the precision and concentrated detail of these verses. This is experimental writing at its best, nurtured within the context of the Encyclopedic Poetry School, which she founded. Yin's poetry ranges confidently over the poetic traditions of both Europe, the USA, and China, modifying and enriching both, borne up by a belief in translation as a crucial and creative stimulus to the inter-play of cultures. Poems such as "Wolfram" are notable for their exhilarating command of English, lexis is confident and expansive; rhythms are sustained yet exciting; argument and dramatic voice carry to fine conclusions. Lines such as these are highly original and deserve to be greeted with the utmost enthusiasm.

—Robin Kirkpatrick
Professor emeritus, Italian and English Literatures
Cambridge University

Xiaoyuan's exciting poetry charts a new path in contemporary Chinese poetry, and this beautiful volume shows her poetic gifts on full display. The rich inventiveness of her poems stems from a combination of her compositional virtuosity, the use of different linguistic and conceptual domains, and the experience gathered from her prolific activity as a poet engaged in translating poems from many cultures. Her poems reveal a deeply original and welcome voice in the panorama of contemporary Chinese verse. An avant-garde artist, she has created a series of unpredictable and stunning poems, which testify to the ingenuity of her poetic talent.

—Jacob Blakesley
Associate Professor in Comparative Literature and Literary Translation, University of Leeds

殷晓媛的创作是非同凡响的：智性构想间充溢的能量、高度的精确性与细节的丰富浓郁极具折服力。实验文本在她的写作中已达极致——对此，她创建的百科诗派所营造的理念语境功不可没。其诗歌以自信的姿态涵纳了欧洲、美国与中国之美学传统，并加以提炼与深化，翻译研究工作使她对于作为跨文化交流至关重要与激发创意原动力的语言坚信不疑。在《钨》等众多作品中，她显示出令人兴奋不已的高超英文技能、其词藻从容自如、绵延极广，节奏克制却又激动人心，争论与戏剧冲突总是巧妙地指向结论。她这一系列特立独行的文本值得读者投入最大的热情去研读。

—[英]罗宾·柯克帕特里克
剑桥大学意大利及英语文学荣誉退休教授

晓媛扣人心弦的诗写所开示的是一条横贯当代汉语诗歌的新道路，这部美轮美奂的著作便是她诗歌天赋的一次全面勃发。她在文辞编码层面的精湛造诣，使她的诗歌充溢着独出机杼的全新构想。她拓展了语义与能指的新界域，作为一位致力于世界文化交互的诗人，她非常丰产，这使她得以积淀深厚的文化底蕴。她的诗歌在当代中国诗歌全景模式下呈现出高度特立独行又引人共鸣的特质。创作出若干变幻莫测、令人惊艳诗歌系列的她，也可以说是一位先锋艺术家，各类作品都充分证明了她的诗歌才华与奇智。

—[美]雅各布·布莱克斯利
利兹大学比较文学与文学翻译副教授

Consistently surprising in their inventiveness and leaps of logic, the poems of Yin Xiaoyuan read like bulletins, fables, case reports and songs built from the wreckage of the information age, but also in accordance with our ancient human need. These poems are engineered to jostle rather than to comfort, and their absurdist surreality often takes comically dark and disquieting turns: "Today a buttery-coated rodent / nibbled away buds of your last wild rose." Nonetheless, and almost in spite of themselves, they make a dwelling of uncertainty amid a dawning doom, giving voice to the way it feels to be alive now: "When you unpack your entire life / On the shore, like windblown sleet, froth and foam will rise / From the center of the ocean, and sweep across your feet …" Riddled with science, the fantastic, gorgeously complex sentences and exhilarating music, the work of Yin Xiaoyuan offers, in its insistence on creating something new and strangely beautiful from the rubble of our world, a modest, unsentimental, and not unwelcome hope.

—Timothy Donnelly
Author of *The Problem of the Many*
Columbia University School of the Arts

殷晓媛的诗歌让读者处于一种持续的惊愕之中，它们如此匠心独具，逻辑线在其中疾冲猛跃，使得它们被赋予新闻简报、寓言、结案报告等五光十色的文本特质，又仿佛大数据时代的信息碎片被谱曲填词，但同时这些文本的内核又与我们古老人类文明的内在需求形成一种观照。它们被"研发"出来，旨在掀起风波而非安于舒适，它们荒诞主义与超现实的肌理通常映射向怪诞的暗调与令人惴惴不安的跌宕起伏："今天，一只皮毛如黄油的啮齿动物，在寒冷的高山上，/啃食最后的火红野玫瑰"（《同素异形体》）尽管如此，它们已超越自身边界，在一种行将降临的末日氛围营构出一处充满不确定性的栖居之所，　由此记叙此在所感知的生命能量："你在岸边，松开自己如解开层层包裹，大洋之上//白沫如涌起自地心的霰雪，跌落脚边/冲洗成片的鸡血石。"（《生存之波粒二象性》）这些诗歌文本中各种科幻、奇幻元素纵横交错，形成极为繁复蔚为壮观的句式，及令人亢奋不已的乐感。殷晓媛的作品执着于在世界的瓦砾之上一件件创造出卓异、绮丽的全新事物，给予人们幽微、冷峻而又不可抗拒的希望。

—[美]蒂莫西·唐纳利
《众数之惑》作者，哥伦比亚大学文学院诗歌部负责人

Yin Xiaoyuan is the founder of E.P.S.—an emerging group of Chinese poets who—by offering new paradigms for the mixing of genres in the Encyclopedic Poetry Movement—have transformed writing with breathtaking language juxtapositions, with the introduction of innovative scientific subject matter, and with astonishing, non-linear representations of reality. Her poetry pushes language to the brink of the undefinable, where the ordinary through a miracle of imaginative alchemy becomes numinous. Yin Xiaoyuan's poetry is powerful, bold, and uncompromising.

—Bill Wolak

Poet, photographer, collage artist, professor

作为中国崛起的新一代文学流派创始人，殷晓媛发起的"智库型写作"诗歌运动，为跨文体创作树立了全新的典范，其令人惊艳不已的语言建构模式重新定义了写作界域，让独树一帜的创意以科学主题为媒介进入人们的视野，其非线性叙事模式下的现实更是震撼人心。殷晓媛的诗歌语言在拒绝定义之域边缘铤而走险、即使平凡之物一旦进入这想象力炼金术的奇观帝国，便获得了超自然的特质—她的作品是强有力的，富有胆略，永不妥协。

[美]比尔 沃拉克

诗人、摄影师、插画艺术家、教授'

Poems given to the physical experience of the world. "Beauty of the universe," says Stefan Klein and it is right because in mass and energy, in quantum and wormholes, between the centrifuge and centripetal forces, life and its opening are settled, its possibility, its permanent path full of appearances and footprints to say yes to the poetic experience. Yin Xiaoyuan knows it and makes it arrive beautifully punctual.

—María Ángeles Pérez López

Poet and Professor, University of Salamanca, Spain

殷晓媛的诗歌构建于世界的物理体验层面之上。"宇宙之美"，斯特凡·克莱因[1]如是说：宇宙是瑰丽的，正是在质与能、量子与虫洞、离心机与向心力……之间，产生了生命及其与世界交互的通道，而通往诸多可能性、亘古不变的路径上，从来不乏探索者的身影与足迹，去拥抱世界的诗性体验。殷晓媛深知其法门，接引这一体验美妙而准时地降临人世。

—[西班牙]玛莉亚·安吉利斯·佩雷斯·洛佩兹

诗人、萨拉曼卡大学教授

[1]指物理学家、散文家、科普作家斯特凡·克莱因（Stefan Klein）的著作《身处无限的边缘：邂逅宇宙之美》（《On the Edge of Infinity: Encounters with the Beauty of the Universe》）。他生于德国慕尼黑，来自一个三代均为科学家的"科学世家"，在慕尼黑大学取得物理学博士学位，专业领域涉及生物物理学、理论物理学以及分析哲学。著有《快乐的科学》《列奥纳多的遗产》《我们都是散落的星骸》等，他的作品被译为超过25种语言，占据多个国家的畅销榜。他曾担任多家科学刊物的编辑、撰稿人，并获得德国科普写作大奖乔治·冯·霍尔茨布林克奖，现为自由撰稿人，文章多发表于《自然》《纽约时报》等主流媒体。

Confucius said that poetry has a didactic function, i.e. to help individuals develop holistic personalities by morality demonstrated through personal influence. Thus, we give lectures that engage us in creating poetry, enabling us to maintain a balance between ideas, feelings, and expressions. Master Zhuang said that literature is a manifestation of Tao—a spontaneous and natural path, unrelated to anything artificial or pragmatic—and that the artist as well as the text are mirrors reflecting the true nature of things.

The phantasmagorical images in Yin Xiaoyuan's poems, resonating with their historical traditions, refuse to unfold themselves in routine scenes. However strange they may look at first sight, they lead us to the enigmatic beginning of the world—"The Hadean Eon" when densities took shape, configuring the Mind to formulate all concepts. The metaphors have contrived a multi-real scenario, in which masculinity, a principle once appearing to be superior to human subjectivity, is questioned. The scenarios are networks deep in the universe made up of LED screens and mathematics (which happened before the concept of "time" as we know it) which manifest as possibilities in other dimensions: "When you glanced away beyond tracks of time, suddenly he came into view, emerging from underneath surface of the ethereal, gleaming with vigor and tenacity. Those attributes of his do not perish with the body, or even with the soul. He is incarnated everywhere, in weather, energy, and even Zen." Like Octavio Paz said, "Light is time thinking about itself."

The web of metaphors has intertwined particles into dense branches of various greenery in the rhetoric forests in which Nature manifests itself in the form of a threat: "mass will inevitably function as / A source of light ... A universe suffused with gluons, photons, and mesons— ... Just in the way souls combine with bodies, / They were blessed with gravity and speed." Instead of finding the originality of this poetry in its rhythm—the translation from Chinese has set barriers for us in doing so—we find originality in the concept of the poem itself. The author has given us indication of her "Quantum Ways," and only by diving deep into the energy fields and the vibrations within could we find the beams of spooky voices and men classified into various archives by scores set according to their structures, so the reader imagines those supernormal, surrealist forms, navigating themselves across the spaces stretching within the poem.

Being the initiator of the Hermaphroditic Writing Movement, the poet extends her verses beyond the realms of transcendence and sublimation; the only way to read her poems is by fitting them into a mathematical universe, where the beauty of equations constructed this extraordinary poetic quality, in a space where parallel realities multiply and project themselves on everything: "The streets that have supplied you with all colors and sounds of life are in a parallel system to theirs."

—Concha García

Ganadora de los premios: Universidad de León (1987) Barcarola (1988), Jaime Gil de Biedma (1995) y Dama de Baza

孔子强调诗的教化功能（"诗教"），提出诗能以人格魅力层面的道德价值裨益于个体乃至全体人民的人格塑造。为达成这一愿景，必须在诗歌创作与鉴赏两个维度上齐头并进，以个体为单位在洞察与表述间建立一种均衡态。庄子也曾讲过："文原于道"，文学乃是自觉与自然之道，不为矫饰或功利所羁累。而艺术家及其作品则是照彻万物本原的镜子。（"夫岂外饰，盖自然耳。"—刘勰《文心雕龙·原道》）

殷晓媛的诗歌宛如绮丽梦幻的走马灯，与古典诗学传统遥相呼应，它拒绝在庸常意象中羽化，乍看似乎奇异怪诞，却将我们引入鸿蒙初开的秘境—极邈远的冥古宙。在那一时空，密度具化为形体，演化出智性，幻化成其中酝酿的万千世相的奥义。在隐喻体系所构筑的多重现实中，她对雄踞于人类主体性之间、被视为典范的男性气质提出诘问。在由网络空间LED屏矩阵与算法建构的场景中，事件超越常规意义上的时间概念而独立存在，概率分布于多维空间中。"你若顺着时间轨迹望去，他是横亘虚无中的顽骨。他在无数个传说中隐显，像一种壮烈或孤绝的性状，并不随灵魂躯体故去。你们看到他，如气羹，如能量，如裨……"（《质数颂》）诚如奥克塔维奥·帕斯（Octavio Paz）所言："光，即会思考的时间。"

在她作品中，纵横交织的隐喻构成文辞微粒，继而繁茂为深浅色阶相映生辉的森林式致密枝叶。自然物理在她笔下呈现出摄人心魄的威势："质量为形体之髓……胶子、光子、介子……直到上帝粒子催发它们，照魂魄的形态生成躯体，伴随以重力与速度"（《上帝粒子，或一茶匙未知元素》）她的诗歌经由翻译通道由中文进入西班牙语境，本身便是一个艰辛的过程，可以觉察到韵律的流失使诗歌的原汁原味有所损伤。我们还看到，在诗的概念内核中，作者将"量子化道路"提上议程，我们只能深潜于能量场中，微粒的振动间，去寻觅其间幻异之声的光线；而人类被贴上数值刻度与机械结构的标签进行归档，因而读者思绪得以信马由缰，与那些光怪陆离的超现实之物邂逅，在诗的太空中自我导航。

作为"泛性别主义写作"首倡者，诗人的创作早已跳脱一般意义的超越与升华之境。只有数学宇宙与它们是自洽兼容的，方程特质之美将这非凡文本架设于特定空间，现实在那里叠加并投射成复层结构："那些为你与他们的成长输送光色养分的街道，是互不关联的两套。"（《质数颂》）

—[西班牙]孔查·加西亚

"海梅·希尔·德·比德玛奖"、"巴萨市女士"及莱昂大学与巴塞罗那颁发的多项殊荣得主

CPSIA information can be obtained at www.ICGtesting.com
Printed in the USA
BVIW121215030320
573815BV00010B/13